Joseph

play

Seyyed Ali Mohammad Razavi Tusi

Iranian writer whose books are published in the world.

He is a young writer from the age of 15 who writes and directs. He now has more than a decade of experience.

Introduction

Seventy years after the end of World War II, the memories of those years are especially painful for the survivors of one of the twentieth century's greatest wars. One of the events that took in this war was the bombing of the industrial city of Dresden in the final months of the Second World War.

Between the 13th and 15th of February 1945, British and American army bombers repeatedly collapsed several thousand tons of explosive and fire bombs over the city. In the operation that leading to the destruction of the

city, more than 1,000 bombers released a total of 4,000 bombs over the city and its inhabitants.

Nora did not have thirteen years in bombing and lived in Dresden with his parents and two brothers. One of its survivors was the bombing of the city of Dresden, Nora. He has survived strangely.

The eighty-three-year-old Nora says about the bombing, "The bombs were falling loud and loud. Every time a piece of coal or a potato fell to the ground, this sound was repeated in my

head. At that time, these sounds became well known to us.

Nora's family survived the bombing. Between the first and second bombardments, while Nora's parents and brother were gathering the necessary equipment, they and their younger brother moved to the basement of the neighbor to be safe. He says the survival of all members of the family was a great chance thanks to the neighboring basement.

Nora says that the survival of the entire family has been a good end to these terrible bombings

and should not cry out memorizing them, but cannot stop their feelings.

In this bombardment, the historic city of Dresden, the capital of the state of Saxony, Germany, known as "Florence on the Great Elbe", was completely destroyed and a large number of civilians were killed. The number of civilian deaths is estimated to be between 12,000 and 40,000, many of whom, like Kurt Vonnegut, who are closely watching the Dresden bombing, cited the death toll in the book No. 54 of 134,000. A US Air Force report in 1953 justified the operation as an exploded bombardment of a military and

industrial target of 110 factories and 50,000 workers in support of German military action. In spite of this, numerous scholars have argued that telecommunication infrastructure, bridges, and vast industrial areas outside the city were not fully targeted. It was argued that Dresden was a major historic and cultural center without any military or military significance, and bombardment of the areas without any distinction between military or non-military nature. I'm wounded every time I kill humans on the ground. There are plenty of lesions that cannot be shaken. I do not think these wounds will be eradicated from human

existence forever and they do not have any treatment. Instead of war, countries need to think about increasing progress. Own in science, culture and literature. The world has become strange.

I have always tried to write and direct plays and scripts from the events and concerns of my life. We artists are all mountains of pain that we can relieve with some effect. Joseph's shows are the cold days of the summer and the trivial nightmares of the war. I hope that some of my wounds will slow down with these shows. Three plays, titled Joseph, are the cold days of the summer, the half-day nightmares of the

war triumphs, where Joseph's play is the first of these three.

(Comes light, Joseph falls down in a corner and calms up, looks surprised around, screaming sounds from afar, and sounds are getting closer)

Joseph:

God Save our Gracious King!

Long live our noble king!

God save the king

Send him Victoria

Happy and glorious

Long to regin over us

God save the king

I did release from prison this morning. For a long time, I had not seen the people. For a long time, I had forgotten everything. At six o'clock in the morning, they opened the large door of the damned prison, which ended in a great desert. I heard a freedom voice. I came out and look at him/her. I don't know

anything, and said all these things at 6am this morning.

God Save our Gracious King!

Long live our noble king!

I don't know, what am I doing here, where is this place? Don't you get tired?! Why don't you stop it? Why did you capture me here? Why don't leave me alone? let me to breathe please.

My ears don't well work like before. I need to well focus until can hear my voice. The world of silence is a strange world. When you walk and don't hear anything, you feel in a cavity

and inside this cessation you are destroying. My eyes cannot see well like before. The world has lost its color and Doesn't exist anything Except black and white. I see the people like a zebra that lives next together ...

The Zebra that is only important to themselves. The Zebra who only lives alone. All of the Zebra that don't understand humanity. damn them. What am I saying? Where is this place really? Others says to me that I say Delirium. I have been given a paper to write. What should I write? Am I a writer? Why do not you understand? Why do not you

understand that I'm not a writer? What should I write?!

Everyone has a professional who has goals for himself, everyone has a plan for life. Why don't you get that? get all these words together inside embed your mind. I'm a pilot. A simple pilot. What am I doing here? I must be in the sky now. I must be high for now and Look at the ground. I want to go away, far and away. I want the earth been a point for me. I want to look at that point ...

I got tired. Why not get out? I don't know what I'm doing, but she said all these things at

6am this morning. she told me I was a pilot ... so, I'm sure ... Oh, Have you ever seen a pilot very close? Have you ever had a talk with a pilot? Tell me, What is a pilot like? That's it?! Like me? I messed up.

she looked at me, lips. I didn't hear her voice. I could lip sync. I saw her face whom was gazing at me. I looked at her. I did not hear anything from her. I did not want to hear. What is important to me? She said to me, your flight wings are me. She said, you are perfect also like before. Just you want two wing for flying in the sky. she told, I'm the same as The former person. Or did not say, I do not

remember. But she said I'm also the same is crazy man. But I'm not crazy. I got tired.

I want to release ... I don't want to be here. What are you doing with me? Why don't you go? Why don't you stop it? Why don't you finish this dirty game? Take a look at yourself. You should Stand on the front of a sturdy, steady mirror. Look at yourself, all of your life it's shit. Why don't you stop it? I'm got tired.

(Joseph slowly lay down on the floor and closes his eyes)

I close my eyes; my ears don't well work like before. I don't like to look at me...

1939 The damn war began. I was just a young boy at that time. A young boy who has just became a professional pilot for himself. I know what you think about me ... I soon made progress. I became a famous pilot. The people knew me. The pilot number one ... The British history had never seen such a that pilot until then. When I got up, you must have watched me and my amazing aircraft roll, everyone was focused on me and my flight. All those old pilots who were down wish to be in my place for a moment ... I was tired. I got tired...

(Gets up and goes to the table)

1939 The war began. That day everything was unrealistic. I don't know whom I was where and what did I do? When I arrived at home, my summons letter was on the table. Tomorrow, I introduced myself to the royal air force when the sun was just rising. From that day we done. I was afraid. I was just a young boy. I had not seen war. After a few days, I was a strange boy... It looked like a game for me. I loved that game so much. I like a game that I loved so much. When I was near German territory, I had good feel, I wish instead dropped one of the bombs on the city,

exploded a bomb on Hitler's head. I got tired … I got tired.

God Save our Gracious King!

Long live our noble king!

God save the king

Send him Victoria

Happy and glorious

Long to regin over us

God save the king

I walked the alleys of the United Kingdom, and I was looking for a warm and fresh drink, I went to a cafe shop. The door of the cafe

shop was opened and Nothing was seen. Everywhere was dark. I entered. I looked at all the tables and chairs. Almost all the seats were full. It was a very strange woman on corner table. I had to sit next to her seat. I apologize for her and sit there. She accepted me with pleasure ... I got tired. I got tired ...

I didn't have a good childhood. When I was five, my father left me. A few years later, I heard the news of his death. He threw himself on the train rails. I didn't sad about her death. I'm not happy, too. I had no sense. He just called his dad. I didn't have any kind of interest to him. When I was ten, my mother

married with a German man. Almost I had no anymore place inside that home. Even my mother didn't want me to stay there. What should I do? Nothing. Nothing? Nothing. ... I got tired. I got tired ...

6 o'clock in the morning different with another morning. she gazed at me also. I don't know what happened in her mind. She/he just looked at me. Her/him face was closed to my ears, I didn't hear her/him voice but as if she Shout. She told me, I will be ok. Everything will be right. Everything goes back to the first days. Don't worry I, I was next to you, and I'm

next to you and I will be next to you. But she didn't know, I was tired … I got tired.

An old man lived around my place. I don't know how old he was. An old man who was very curved. That old man had accepted me as a guardian. he registered me at a school near my place. I and he went to school Every morning. I was embarrassed by my classmates. Not because I didn't have a parent, not because I didn't have family, just because the old man had not enough money to live, and I was Overhead of him. Now when I think about it, I'm laughing that a little boy thinking about money … Have you ever

thought of overhead? Feel that you were dead and you will never be there? I got tired... I got tired.

Almost, I was a major element in all of bombing missions and became more popular every day. I was never a murderer, but I had to do it because that was a war. The war doesn't care about old and young people, or girl and boy, the dirty war. I was never a murderer, but I had to dropped dead bombs on life people. I had to kill them. (Angry) I was never a murderer. I got tired... why this game is not over. What is my destiny? Why not stop it? I got tired... I got tired.

I ordered a coffee, a very dark coffee. She was busy working. I'm drinking my coffee. It was very dark until I didn't drink coffee like that before. I was a few hours in the cafe shop. I liked her, she was a strange girl. We talked together. We chatted and drink coffee ... she wanted to help me ... I got tired ... I got tired.

I went out of school. The old man stood in front of the school door. He was very interested to me. He never had a kid. But he liked me also his son. as if I was from his family. We went to home; I was look at his. He was sick, I got he will have gone. I didn't do

anything. What could I do? But I was tired for all of things. I got tired… I got tired.

I was looking at the paper and pen. As if I had to writing some things now. As if I had to pretend that I'm a stupid writer. A crazy writer. A writer with words predefined by them. I'll get white paper. All of it was white … they didn't understand. They order to me that write. I didn't know what to write. What should I write? Every day, so many people with strange clothes were around me. I do not know they are going to help or harass me. They are transferred me just like nurse. They are like a

medical team to help whom want to be a good person. I don't know what I'm saying. I don't know anything. I got tired... I got tired.

Everything was fine, until that day. A message arrived from capital command. the general has gathered all senior pilots to speak. We got together at The appointed day and certain time in a certain place ... we were all ready for the general to begin. I just wanted to talk to the general only. I'll saying I'm tired ... I got tired.

We came out of the cafe shop. We were going forward. She told me that we would walk in

the British streets tonight ... until morning we were all over the place and talked about our lives. I didn't want that night to end, when I looked at the sky and saw a light from the sun, I was afraid ...

In the pass others says to me whom I'm impatient, I'm a crazy person, I'm a Secluded person ... they saying, nobody cannot stay with you. But I fallen in love that night ... what's love?! I got tired... I got tired.

I found myself, got it that the old man will be to gone, he could not even walk. I should wear it every day. I was fifteen. I should to care him.

I should to help him. When I needed to help, he took my hand and made me bigger ... his body became cooler. I felt the cold of him body. I feel this cold from the beginning of my life. It's a strange thing. Clothes heat doesn't do anything ... I'm cold. Help (pause) one night when the weather was very cold. One night it was so cool that the heaters in the old man's house did not do with the cold. A screaming voice came out. I wake up and got up. I went to the fridge and drink water. When I came back to the room. I saw the old man whom was white with all his skin. I went next to him and seat. I got him pulse. Him body

was frozen. As if a few hours he had gone. I got my head on his chest and I was lying there until the morning. I don't remember anything. Only the siren sound of that fucking ambulance is in my mind and it will not be erased. I got tired... I got tired.

General, as usual with his defensive team arrived finally. He has delay. began talking. That day was ever more serious, more nervous and more decisive. I thought it was weird. 1945 was a whisper of world peace. Initial conversation was held for peace. I don't know for all this anger. He continued his words very seriously. very serious. I looked at around me.

How many of my friends have been killed in those years? A series of new people around me whom I did not know them. I was very stranger. I got tired... I got tired.

I got to him home quickly. That night, she could not sleep, when I told her to going to war and introduce myself, he did not sleep until morning. she was sitting behind the window and look at street. I talked to her. I tried to calm her but was useless. She was very upset. she told me if you leave me, I'll be killing myself. she said that if you leave me, I'll be destroying... but I left him. I should have introduced myself to the British Army. I

reached that place at 6am o'clock. I got tired... I got tired.

The sound of those are sirens in my mind. I will never get erased of my mind. I saw the guys going to him home. Others says that guys were him kid but he didn't have kids. I don't know how they understand the old man dead news. When they arrived home, they began screaming and screaming, which I never understood. The old man told me he hasn't any kids. The old man told me that he had just married whom was separated from his wife. I don't know where they were found to plunder

everything. I left that place forever and I didn't want to come back. I got tired... I got tired.

After six years of war, when we were all tired, we had wish that will be peace still we can get back home and our lives. I thought to myself that day, when we arrived at that important meeting, the general would probably like to thank us, but the game went back completely and everything changed. We entered a new stage of our lives. That day, General said, we should be prepared to attack Dresden in the next few days. General discourse were strange. I do not know why chosen Dresden to attack. I only know that all of soldier's family refuge in

Dresden. I just know that they have no weapons to defend themselves. I just know destroying Dresden, that is mean, destroying Germany. all of them is stupid, but I'm not happy to die so many innocent people who did not even interfere in the war. I'm not a murderer. what? Why you look at me like that? Did you think stand up a murderer your face? Did you think I don't understand? I'm not a murderer (Shouting) I'm not a murderer... A few years later I heard that the Nazis Slaughter my mom ... first I got upset. But then I didn't care about it. I had learned to be selfish. I got tired... I got tired.

One day we were walking in the alleys of the British. I was reviewing my memories. I was defining it all for her. We walked away from the old man's house. The poor old man had a hard life. He was alone. when he died, his family catch his Property and property. Although the old man had nothing. When we looked at his home, we saw even the doors and windows of the home being cached and stolen it. It was just an empty home.

I don't know that who am I, what am I doing and what I did. she said in my ear, this morning ... she took me a piece of paper. she told me this is your identity. She said me, you

are name is Joseph, poor Joseph. she told me that I never leave you. She told me that she was waiting for 16 years for me. I do not know why it was 16 years, but she was waiting for me. I am a strong man. She told me that the sooner we went to the hospital to change my blood. She told me exchange your dirty blood Instead clean blood. she said everything Depends to our eighteen and nineteen years. She Saying, do not worry ... poor Joseph. Where is she now? can she look at My destruction? Can she have a seat and do not know what's going on? Joseph is tired ... I got tired.

General said everyone whom wants to do this mission, stay and others goes to the freedom life. general spoke of democracy. general take us an options. He said the choice with yourself. He said those people that are ready to bombard the city of Dresden stay, and those people hasn't Conscience go to home, they are freedom. I arrived to end line of the pilots. I wanted to escape from that line ... general said right. Maybe I was a coward, maybe I was not a warrior, maybe I did not a soldier. I cannot see the city where many people are killed. So what would my conscience be? That's right they are Nazis. That's right they are killing so

many Jewish, but my conscience was not satisfied that innocent people would be killed. I left that place and don't went came back that place. I got tired ... I got tired ...

I look at my id card. According to these id card, my age is thirty-five. War is over? Did we win? I went to war while was a twenty-year-old boy who was just a teenager. I contended missions to success for six years. But unknown is these ten years. Where am I for that ten years? She caught her head on my shoulder and stared to cried. she said, I changed a lot. she said, "I'm not before person. She said I am a person destroy. Given to me a paper to write.

As if they understood I'm not a writer. I am a pilot. I must fly. What do I do on the floor? the stupid guys destroy me.

I'm broken. That day, when I run from general and his missions, they catch me and They imprisoned me. I have no idea what I saying, but she told me all of things at morning. she told me I'm crazy. They said I lost my celebrities. They said cause I was so high that it would not be intelligent. But I was not crazy. I was a healthier than them. but she told me all of things at morning. ... said, do not worry about anything. She said don't fear, everything will be fine finally and we'll be

back home. She told me that I lose my mind when I was in asylum for ten years. She told me, I'm crazy because drugged, and I don't use any cigarette in my life ... What should I do? Should I fly on the innocent people? Should I kill everyone? Should I have destroyed that city? Where that pilots whom did this? Can they live comfortably? Can they nice live anywhere of this world? Can they forget about the past? They are a dirty pig who cannot understand humanity. But that called war. you kill people and people kills you. Without any principles. Nobody knows the principles and rules Except Country leaders ...

Who are the people who is my fans? Where is the general whom worships me? Why am I forgotten? This is not the life ... she told me All of things at this morning. She said that after ten years, when I was in that asylum, this morning, I released me. she said that finishing bad days. Saying everything will be fine. she said I love you ... I have no idea who was she and what was she. I didn't understand anything from her talking. Nothing. I gazed at her as she gazed at me. her face wasn't familiar to me. She Had a strange face. As if she has bad years. I have no idea who was she, but she was a strong woman. She was in jail. She said

they had been imprisoned. she had no money to live. She had to steal, she had to stole a little food for his life, she was imprisoned for stealing potatoes. She was pregnant in prison... I went to war because people like she, have nice life ... I have no idea, why the Great Britain kills people. I'm wrong. ... what am I saying? Where is it here? Who are you? Leave me alone. What are you going to? Why do not you stop it? I got tired. Why do not you understand who I am a pilot ... I'm not a writer. I cannot write ... I lost my friends in front of my eyes. they were Slaughtered. why I'm not die? Why I'm not arrived to end? Why

do not you finish this dirty game? I have no idea what happened to me during these ten years? I have no idea what to do with me? I just know I do not remember anything. Nothing. They throw me in a bucket like a junk. She told me all of thing at this morning. Why am I a Jewish? Nazis doing same this really?! Why is not our generation extinct to live a comfortable world? We destroyed everywhere and we broke up everywhere ... Us is the main cause of our war… sometimes, I thinking not different if I was Nazi. country leaders War is the lose game. You are a loser Finally. They are

made good soldiers by his emotions for their Crown. I got tired… I got tired.

she was like my wife. just like whom I met in that room. This morning, she taken me to that room and said to me all this thing … I told her don't worry. I told her, I quit this damn drug, I said to her, I stood like a mountain of your back. She cried with Smile and put his head on my shoulders. That girl who had met her in the café shop, and been my wife had been waiting sixteen years for me, now I'm came back and I want to live, but whatever I think she is not like my mistress. how broken she. After a sixteen years I came back and live and I

want to live ... Once upon a time, I wish they shot me when I left General and Pilots stile I never saw this day. How did they do that with us? Really, how should do live? Really how should do live? When drowned the world in war and killing, how should do live? Really, how should do live?

At 6am o'clock in the morning, she put her head on my shoulder, she saying that I was her behind, she said, In the world, I only have you and you are my love" she said that I was waiting for 16 years, she said I had been fighting in sky for 6 years and I was at asylum for 5 years, she said they were demolishing me,

said I the glory of the United Kingdom, but now I'm nothing. she heats Jews, why are we were born in Britain ... how should I live? (Thinking) why don't I die. Why did they hurt me? Why do not they leave me alone? Why did they do that with me? I got tired... I got tired… why don't understand whom I got tired?

(lay down on floor slowly) But I will be living. I will be starting again. I don't care what's happened, it's important that I will be starting again ... she told me be strong, you're a strong guy for bad days. she said everything would be right. We would to migrate from this damn

country, live there comfortably and have children and we would just be living ... we will old together, older than what we are (thinking) Where is she? I'm here, she left this room, I did not see her at morning. she will be back. she said we would start again, rent a little home, and live together under the ceiling. she said the British Army would give us a home and money to live, and we can sell it and leave here forever. I got tired... I got tired...

The British army knows what I've served for 6 years. army will help to me, I'm sure. (Thinking) I got rid from damn asylum at 6am. I came from the door; I look at her that

standing alone. she was saying my wife. she was so trying to my freedom ... I did have looked at her. She was Broken, it seemed like she was 20 years older than me I have no idea, how should live!

God Save our Gracious King!

Long live our noble king!

God save the king

Send him Victoria

Happy and glorious

Long to regin over us

God save the king

(Joseph take his mirror in his pocket and looking at the mirror, the light going, It comes out the screaming sounds and sound of dogs from far away)